Barbie™

First published in the United States of America in 1998
by UNIVERSE PUBLISHING
A Division of Rizzoli International Publications, Inc.
300 Park Avenue South
New York, NY 10010

and

THE VENDOME PRESS

©1998 Éditions Assouline, Paris
English translation copyright ©1998 Universe Publishing

Front cover photograph: Special Edition. Long sheath of gold embroidered satin with
side panels of taffeta and velvet. © Helbert Noorda/Italian Vogue
Back cover photograph: Marina Spadafora. Handmade passementerie coat worn over
a stretch dress. © Helbert Noorda/Italian Vogue

Text and captions translated by Elizabeth Heard

ISBN: 0-7893-0247-0

Printed and bound in Italy

Library of Congress Catalog Card Number: 98-61197

UNIVERSE OF FASHION

Barbie™

BY FRÉDÉRIC BEIGBEDER

UNIVERSE / VENDOME

SUPERMODEL BARBIE

Even though I'm a real man's man, I have been enamored of Barbie since the tender years of my youth. Growing up as a little boy is miserable if you have to play with boring things—electric trains, lead soldiers, Lego or Tinker toys—instead of hanging out with that fascinating doll. I have bleak memories of endless Monopoly parties where all my buildings ended up heavily mortgaged while Barbie slept in my cousin's closet, with no one to wake her up and pamper her. . . The word "gloomy" seems to have been invented to describe afternoons without Barbie.

But who exactly is this mysterious blonde with her perfect smile? Very simply, the most popular doll in the world. 120 million are purchased each year worldwide that's two per second (or sixty four since the beginning of this text).

born on March 9, 1959, Barbie owes her existence to Ruth Handler, the wife of Mattel's founder, Elliot Handler. She was the mother of three children, Ken, Skipper, and Barbara, whose nickname (as you have surmised) is borne by the tiny supercelebrity. Barbie owes her flawless figure to Jack Ryan, a talented designer with a fondness for pretty blondes. The first adult doll in the history of toy-making was officially introduced in New York in 1959 as "a teenaged model dressed in the latest style." She focused on becoming a serious shopper right away: silk dresses, jeans, suits for daytime, beach outfits, and clothes for indoors. Countless accessories (handbags, shoes, sunglasses) all became utterly irresistible. Did Barbie need to organize her fabulous wardrobe? Soon there was furniture and then an entire hyperrealist environment of pink houses with pools, luxury cars (a red Porsche cabriolet, a pink Cadillac), campers, and yachts. Was Barbie bored? Then bring on some friends and a family: after Ken (the boyfriend) and Skipper (the little sister), along came Stacie and little Shelly (new sisters), then Midge (another friend), Stacey (an English fellow), Christie (her black buddy), etc., up to Twiggy, the uncontested star of the 1960s, who came to thumb her nose at Barbie while flaunting her Mary Quant look.

And Barbie adapted, changed, transformed herself. She followed fashions and she followed her times. She reflected her times. To prove this point, think of the entertaining joke that made the rounds last winter, so effectively summing up our contemporary Western society. Setting: a toy store at Christmastime. A saleswoman is showing various new items in the Barbie line to a customer: "Now, here you have Barbie as a bride for $10, Barbie in a swimsuit for $10, Barbie in a ski outfit for $10, and. . . Barbie as a divorcée

for $1,000." The customer asks, "But why is the divorcée Barbie so expensive?" The saleswoman answers, "Oh, you see, with the divorcée Barbie, you get Ken's apartment, Ken's country house, Ken's car, Ken's plane. . . !"

ut the really inspired achievement of Barbie's designers was, of course, to make her the first supermodel. Before the era of star models, this doll was already changing her wardrobe for each season, drawing from an abundance of collections in every style, for every taste, all of them up-to-the-minute: miniskirts in the swinging sixties, counterculture cool with fringed jeans in the seventies, the Dallas/Dynasty drop-dead rich look in the golden eighties. . . No other toy was such a perfect reflection of the development of fashion over the last forty years: It seemed perfectly reasonable to dedicate a book to her on the occasion of the Universe of Fashion collection. Claudia Schiffer and Karen Mulder were not yet born when Barbie was already the symbol of the superwoman. It is even likely that Claudia and Karen wouldn't have grown up to be supermodels if they hadn't played with Barbie as children and longed to grow up to look like her. . . In vain, of course, since no real woman could ever be in the same league (talk about neatly turned ankles—hers are about 3 millimeters around).

Barbie's real strength is precisely that she couldn't exist in the real world: Like Kiraz's Parisian women or Lara Croft, the virtual heroine of the video game Tomb Raider, the Barbie doll is exalted by her own artificiality. She is the first cybercreation—a sexy version of Frankenstein's bride. She dates back to an era before the progress in plastic surgery (silicone-enhanced breasts, collagen-

6

swollen lips, actresses who look like Donald Duck. . .), but she was a smiling mutant well before pitiful humans wrecked their bodies in an attempt to achieve her impossible measurements (95-45-82!). On a recent trip to New York, I visited the famous toy store FAO Schwarz on Fifth Avenue to view their Barbie line. Those fiendish New Yorkers had entertained themselves by enlarging Barbie to human dimensions! A catastrophe! Worse than Pamela Anderson! This is a vital point: It is of paramount importance that Barbie never exceed her original height of 29 centimeters. Let us never forget her essence: to be the first baby-sized adult doll.

though she is often accused of symbolizing the woman as object, you could say that when it comes to feminism, Barbie doesn't need lessons from anyone. She has worked since 1959, first as a model, then successively as an astronaut, disco queen, airplane pilot, ballerina, and presidential candidate in 1992! She is very "politically correct," and actually almost a caricature of the liberated woman. "You know it's not so easy being a liberated woman," as a song from the eighties puts it. What's more, her physical appearance has evolved to keep pace with public demand: There are Asian Barbies, black Barbies with afros, Hindu Barbies, Japanese, Jamaican, and Mexican Barbies, with darker or lighter skin, etc. Barbie is absolutely jet-set, "United Colors" to the bottom of her heart. In 1998 she actually assumed a new face, fresher and less made-up, more impish and less adult than the classic version. She has light chestnut hair with short bangs. Let's just say she looks more like Kate Moss than Claudia Schiffer. Yes indeed, the wheel turns: Pretty soon Barbie will end up looking almost like us. . . You'll see.

As soon as she had a home, Barbie developed a decor that was frankly kitsch, with bright colors recalling David Hockney's work or the pop art so dear to Mr. Warhol. Her world was eternally clean, spotless, immaculate. Everyone had a smile for her. She'd go horseback riding before coming home for dinner in a pink house à la Barbara Cartland.

t o keep herself busy, she does good deeds by supporting noble causes, just like the late Lady Diana. Some of the work shown in this book includes couturiers and designers of the nineties, each of whom created an outfit for Barbie for an auction organized by Christie's and Italian *Vogue* in Milan to benefit the war against breast cancer (title of the event: "A Barbie Today to Save a Woman Tomorrow"). All the most avant-garde designers, the new generation (Tom Ford for Gucci, Miuccia Prada on her own behalf, Jean-Paul Gaultier, John Galliano, Vivienne Westwood, etc.) took scissors in hand to turn her into a fashion victim.

But this wasn't the first time. Traditionally since the sixties, all the world's greatest couturiers have agreed to create one or more designs for Barbie (notably at Mattel France's request in 1989, 1995, and 1997). Barbie was on display right from the beginning. There's been a regular fashion show in museums all over the world. The most recent. . . at the Chateau de Chamerolles in 1998. More than three hundred Barbies have been in fashion exhibits since 1959! From Christian Dior to Sonia Rykiel.

Stylistic exercises say a lot about artists, especially works done on commission. It is interesting to observe how designers have gotten around the constraints relating to the doll's size and

reputation. Azzedine Alaia made her a brunette in a pilot's jacket; Armani pictured her in an airy silk evening gown à la Audrey Hepburn; Dolce & Gabbana wrapped her in a magnificent coat; where Gianfranco Ferré saw a Hitchcockian heroine, John Galliano sketched an aristocratic punk; while Jean-Paul Gaultier and Marc Jacobs dreamed of her in a winter sports village setting in Gstaad, Gucci made her an Ivana Trump clone and Calvin Klein created a kind of Janice Dickenson on her way back from Peter Beard's; as for Christian Lacroix, he fantasized about an outmoded ultrawoman reminiscent of Sydne Rome in *Creezy*; Levi jeans pictured her in a remake of *The River of No Return*, and Alexander McQueen made her right at home in *Tarzan*. Moschino remained faithful to his fantasy, Prada to her austerity; and while Versace turned her into a sexual bombshell, Vivienne Westwood endowed her with the indispensable cachet of fiercely British eccentricity.

t here's one for every taste. Barbie is an inspiration to artists because they are simply grown-up children. And I find myself thinking that, at the end of the day, maybe the most wonderful thing about her is the way she reimmerses us in untouched childhood, a world without unemployment, an existence without misery, without death, without despair. In contrast to us, Barbie never questions things. When you think about it, capitalist society has produced much that is a lot worse than Barbie: Nuclear power plants are far uglier and manic cops are a lot less reassuring. That's exactly the saving grace of this universal doll: She isn't serious. She is completely deserving of her seat on board the Voyager, the NASA probe which carried her to the limits of the

universe. In the future. . . far in the future. . . when the Earth has exploded, aliens will perhaps encounter a Barbie doll drifting in space, and her fixed smile will give them a good idea of the essence of the American dream in the second half of the twentieth century. Deeply moved, the aliens will declare her to be a goddess and will offer up this prayer in an invocation: "✳✳✺✳☉‿ ✓✳🔄 ❑✿✳✳ ◆➁ ! ✿✱✸ ▷ ‿❑❣☆✳ ! ➁◐☉❑✿✱✿✱✳▱. . .", which has its own sort of poetry. Although these utterances are, strictly speaking, untranslatable into terrestrial language, I will nonetheless attempt to convey an interpretation:

"Barbie smiles upon the stars,
Barbie surfs the Milky Way.
Barbie's hair is illuminated by the sun.
Barbie drifts among Saturn's rings.
Barbie has departed, Barbie has gone away.
Does Barbie sometimes shed a tear?
Does she have pity for the fate of wretched mankind?
Does she love them just a bit?
O Lord, may Barbie protect us."

Couture Houses and Designers
Who Have Dressed Barbie

Azzedine Alaïa
Victor Alfaro
Fayçal Amor
Giorgio Armani
Agnès B.
Balenciaga
Pierre Balmain
Claude Barthélemy
Jean Barthet
Luisa Beccaria
Anne-Marie Beretta
Éric Bergère
Laura Biagiotti
Antonio Berardi
Alberto Biani
Manolo Blahnik
Blumarine
Cacharel
Stella Cadente
J.-Ch. de Castelbajac
Chloé
Corinne Cobson
Enrico Coveri
Coveri You Young
Raffaella Curiel
Alessandro Dell'Acqua
Christian Dior
Dolce & Gabbana
Dorothée Bis
Jacques Esterel
Jacques Fath
Fendi
Louis Féraud
Gianfranco Ferré
Alberta Ferretti

John Galliano
Nathalie Garçon
Jean-Paul Gaultier
Genny
Nikita Godard
Grès
Gucci
Olivier Guillemin
Lee Young Hee
Lecoanet Hemant
Hermès
Iceberg
Marc Jacobs
Stephan Janson
Patrick Kelly
Calvin Klein
Michel Klein
Krizia
Christian Lacroix
Odile Lançon
Olivier Lapidus
Ted Lapidus
Guy Laroche
Hervé Léger
Lolita Lempicka
Léonard
Véronique Leroy
Lesage
Levi's
Jérôme L'Huillier
Mlle Zaza pour Scooter
Max Mara
Alexander McQueen
Missoni
Claude Montana

Popy Moreni
Hanae Mori
Moschino
Rifat Ozbek
Guy Paulin
Prada
Paco Rabanne
Georges Rech
Nina Ricci
Lorenzo Riva
Rochas
Sonia Rykiel
Jil Sander
Corinne Sarrut
Jean-Louis Scherrer
Mila Schön
Élisabeth de Senneville
Junko Shimada
Jean-Marc Sinan
Francesco Smalto
Franck Sorbier
Marina Spadafora
Lawrence Steele
Strenesse
Anna Sui
Angelo Tarlazzi
Atsuro Tayama
Chantal Thomass
Torrente
Philip Treacy
Trussardi
Emanuel Ungaro
Ventilo
Gianni Versace
Vivienne Westwood

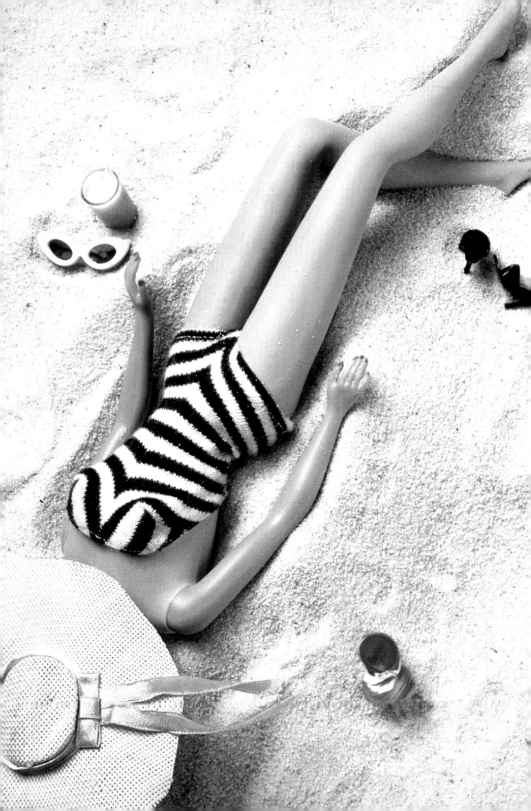

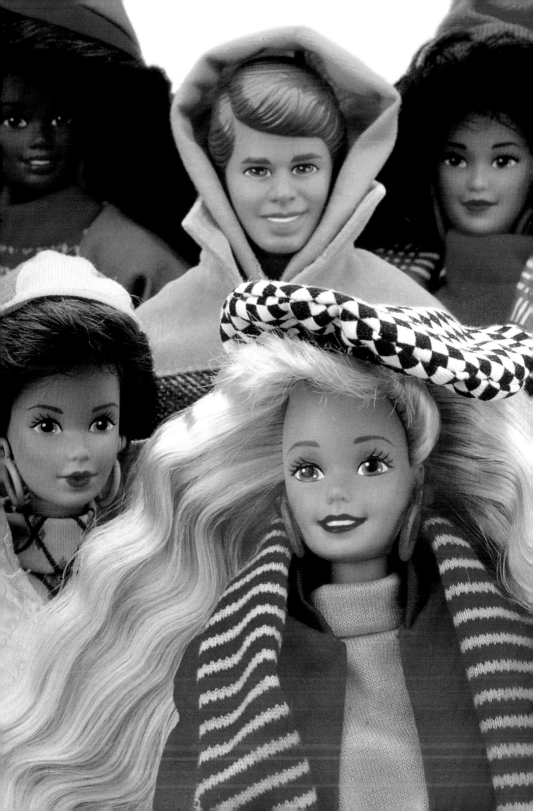

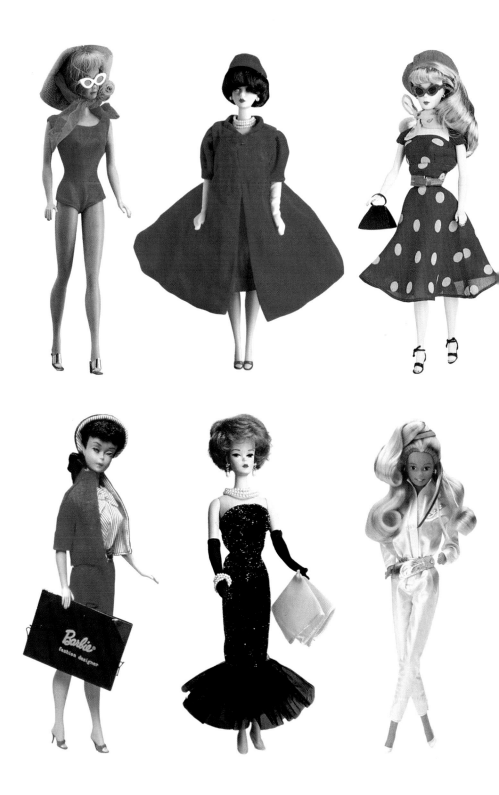

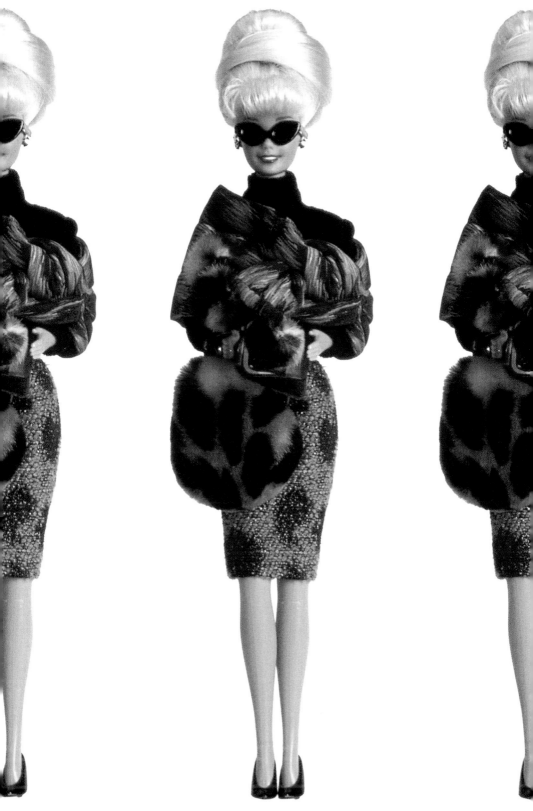

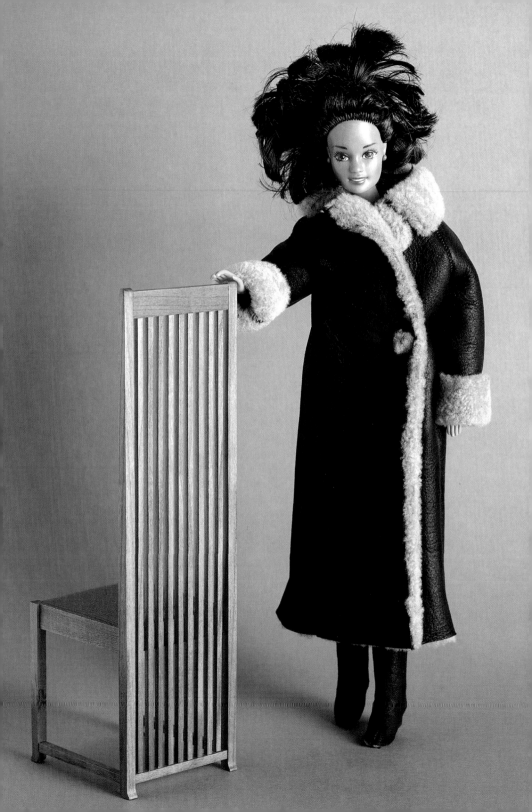

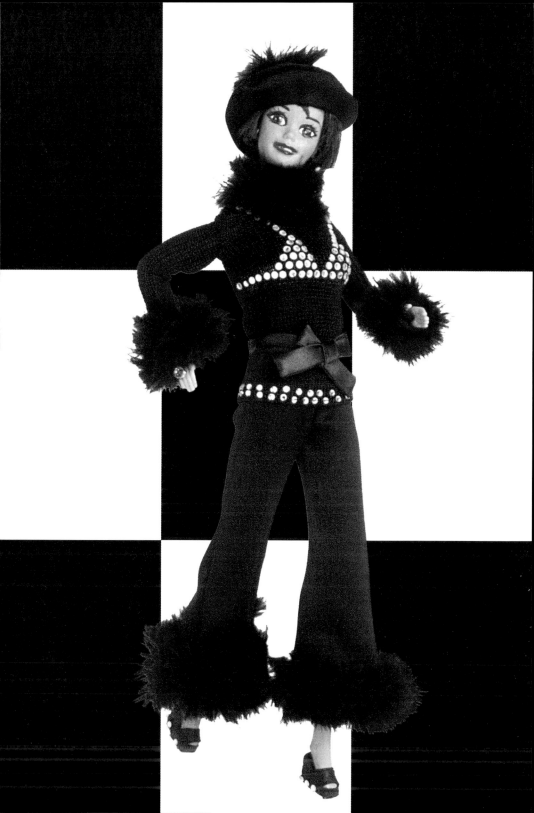

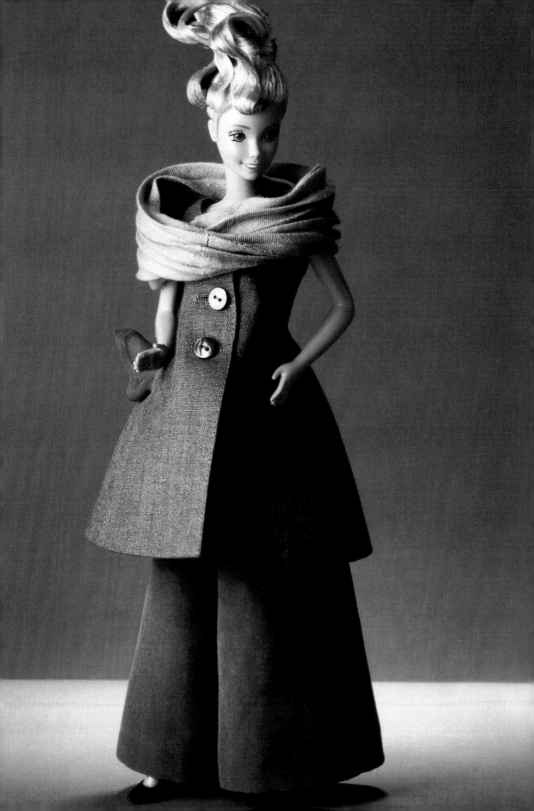

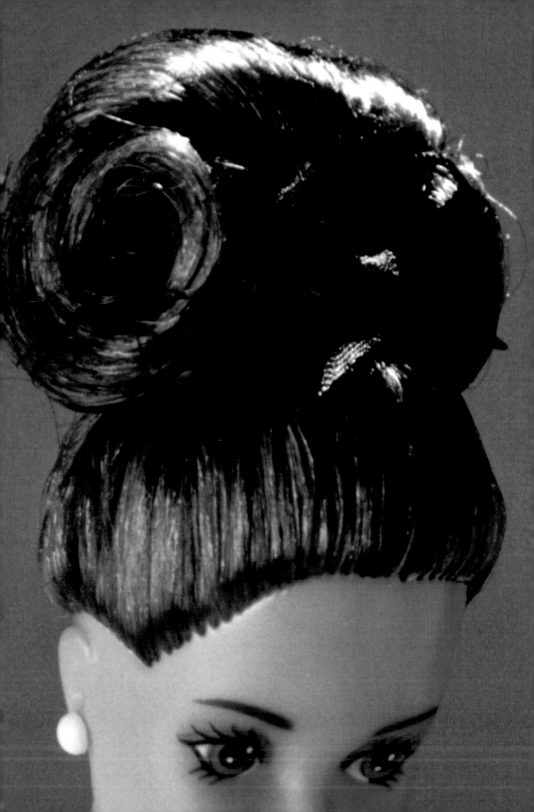

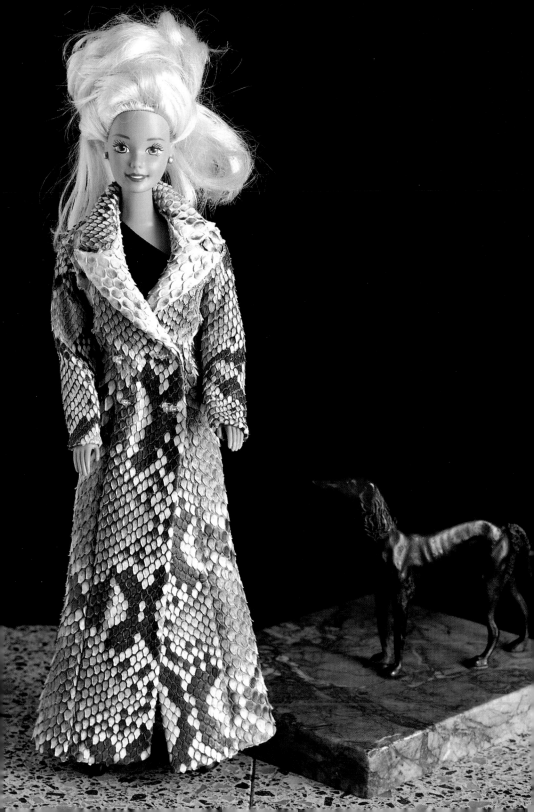

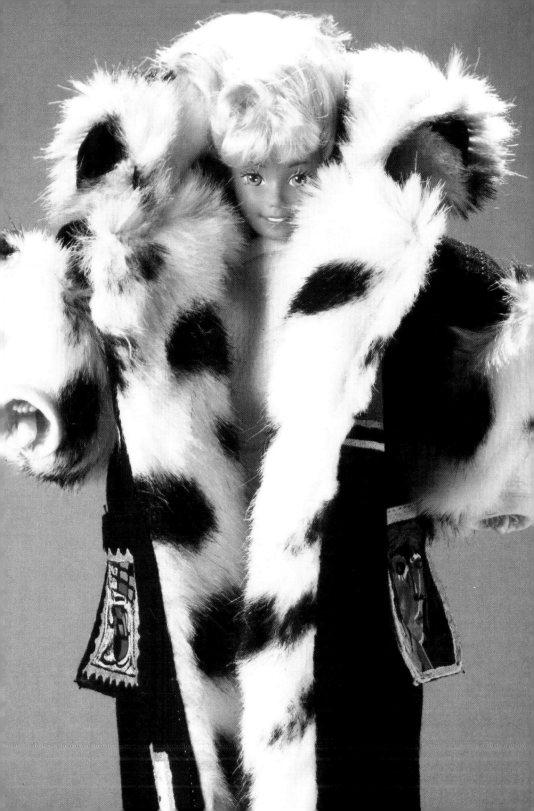

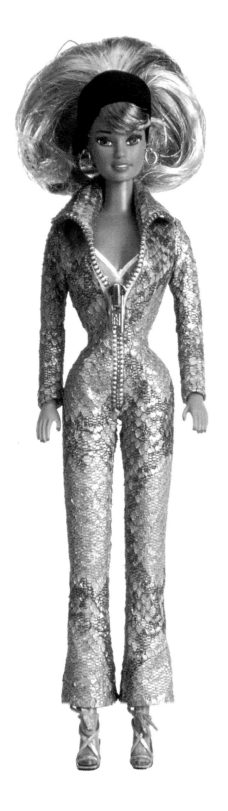

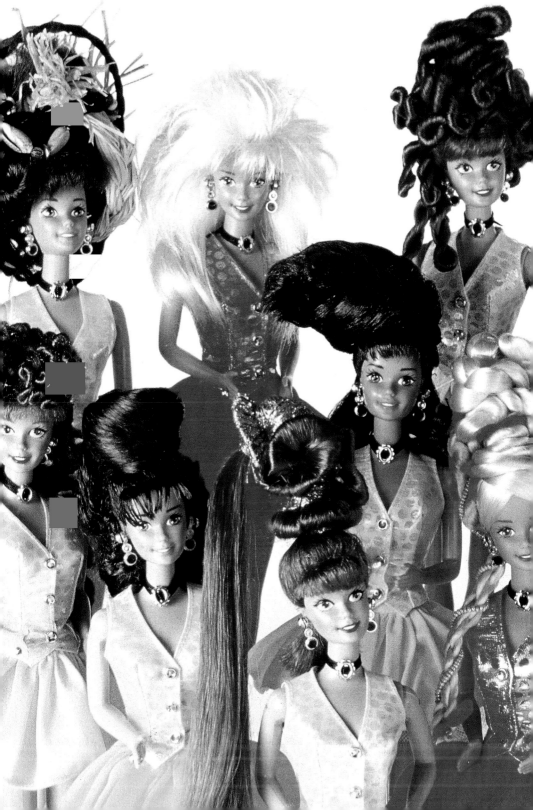

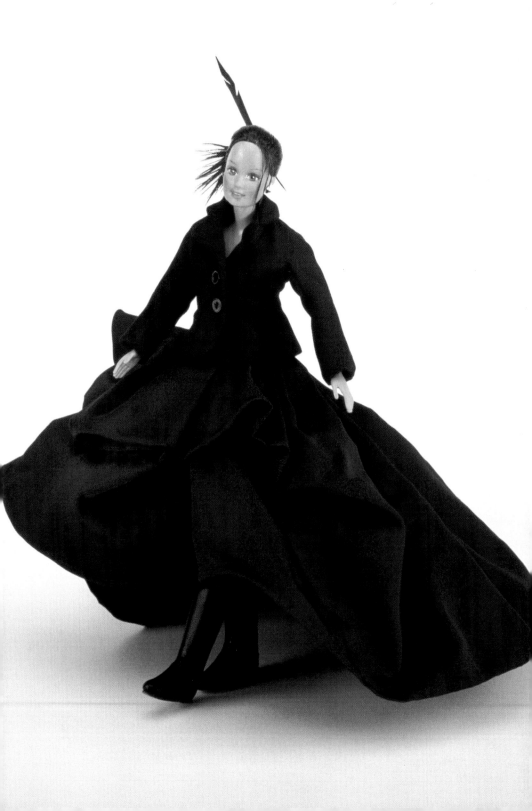

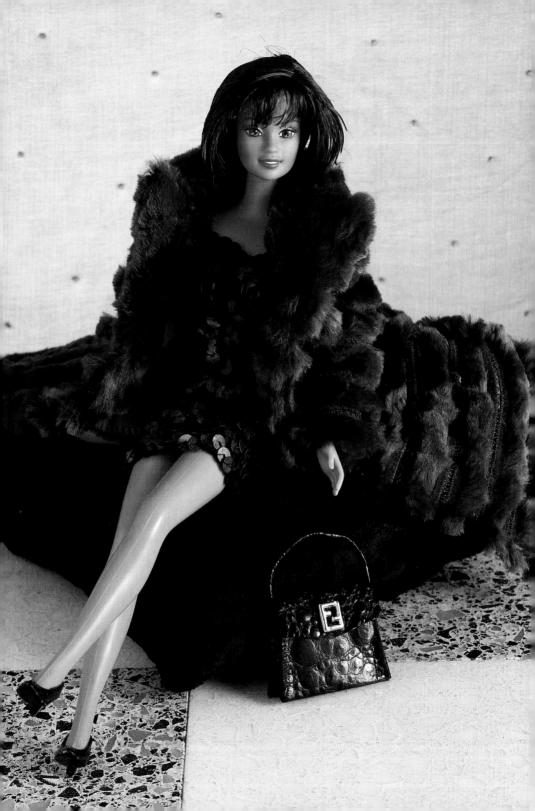

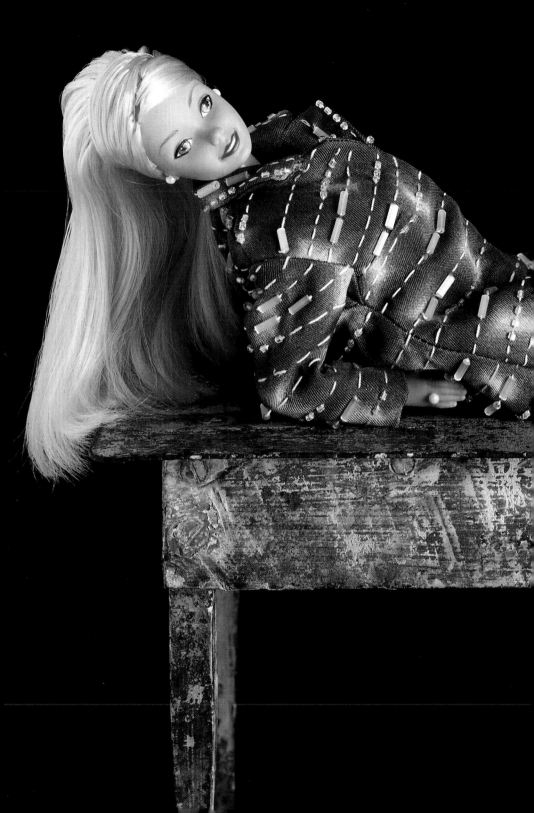

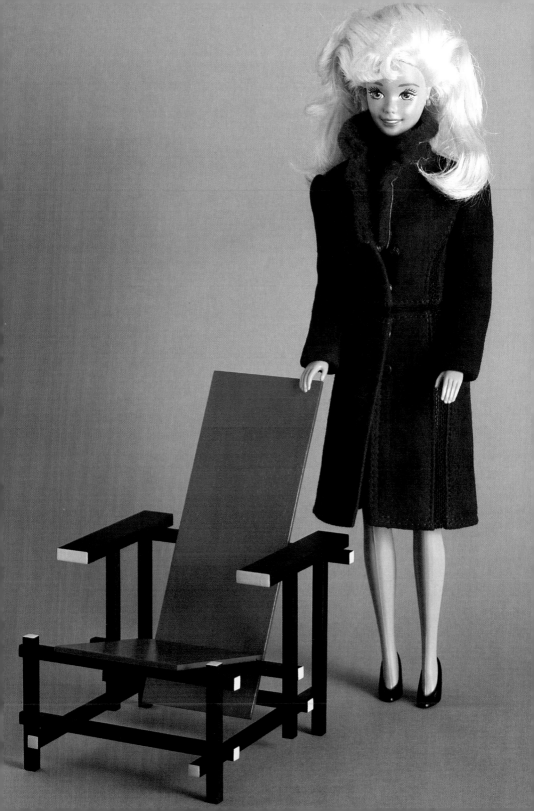

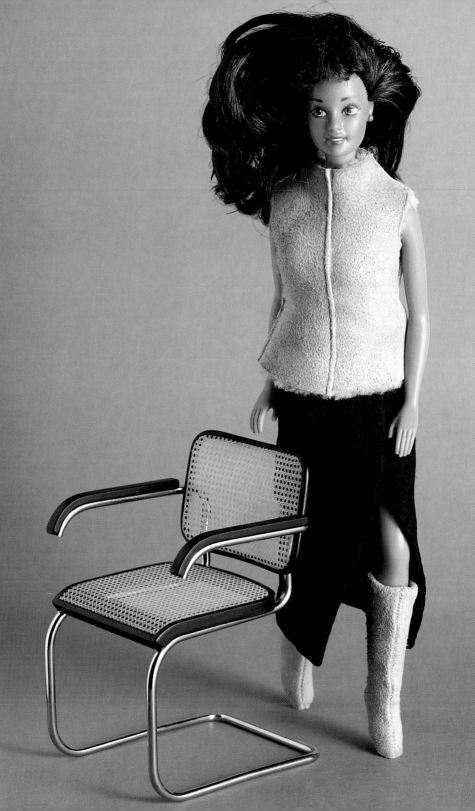

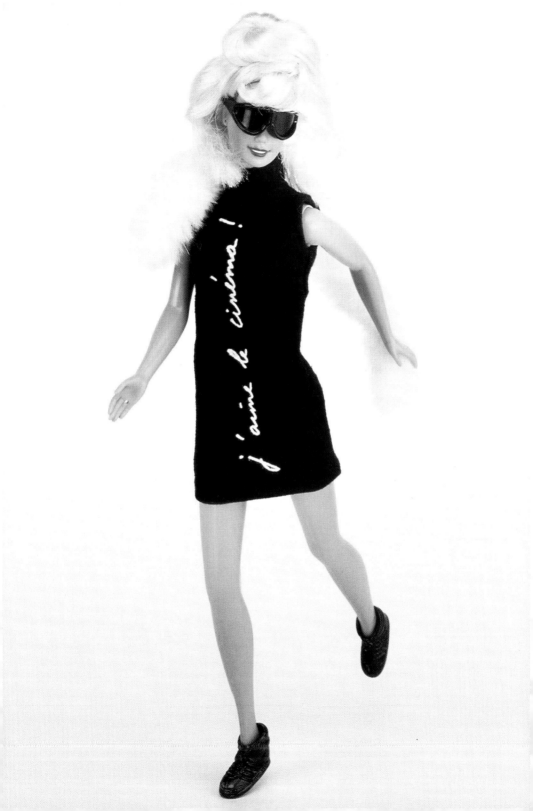

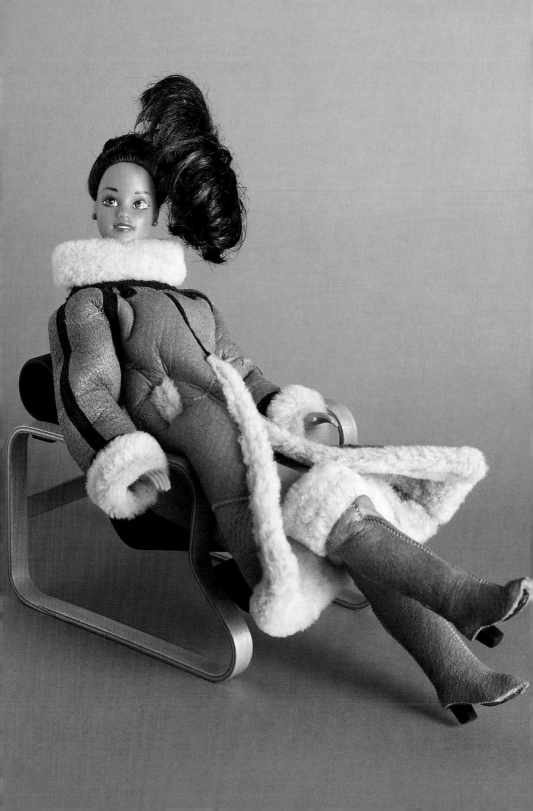

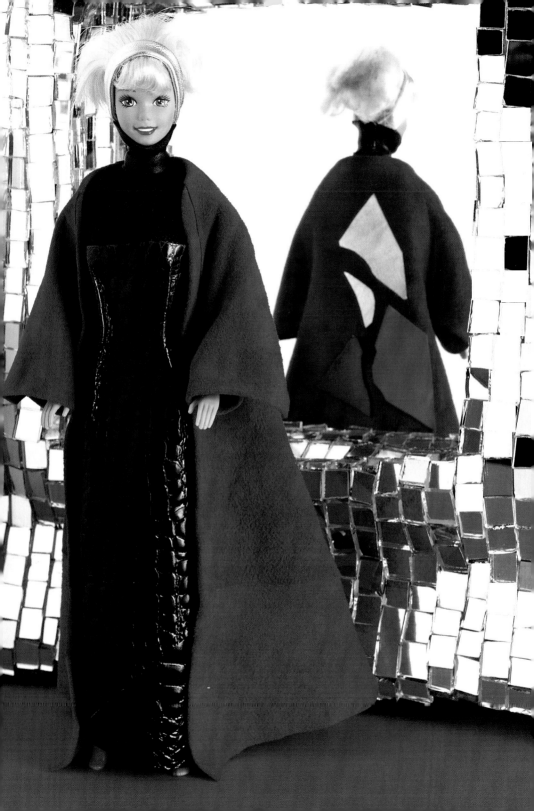

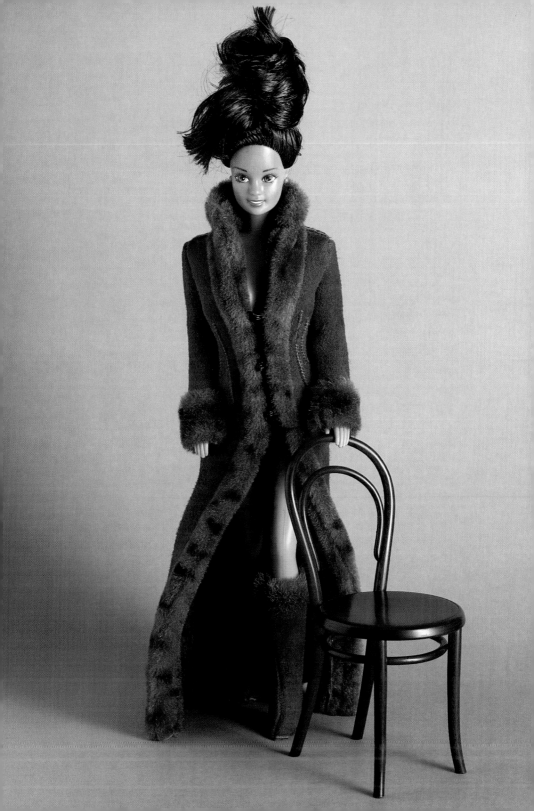

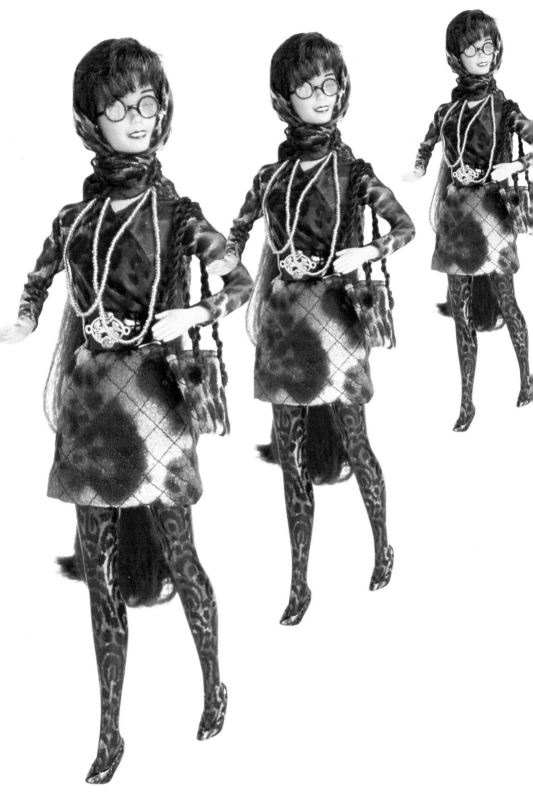

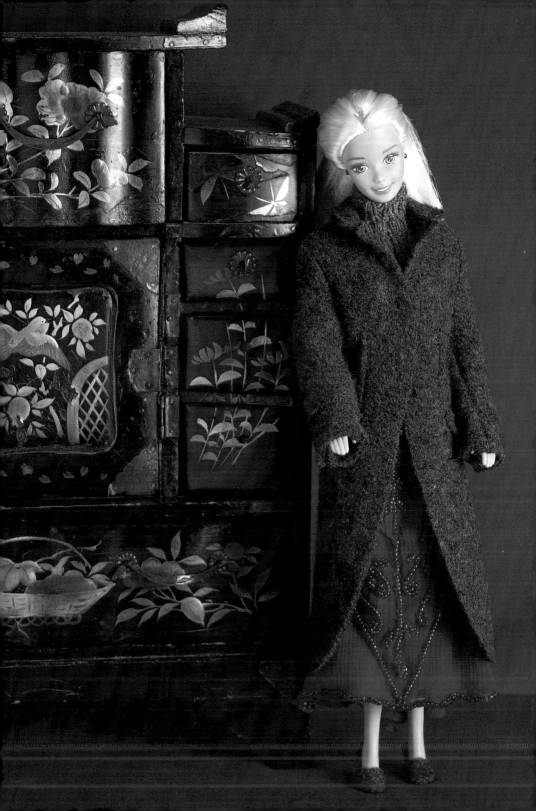

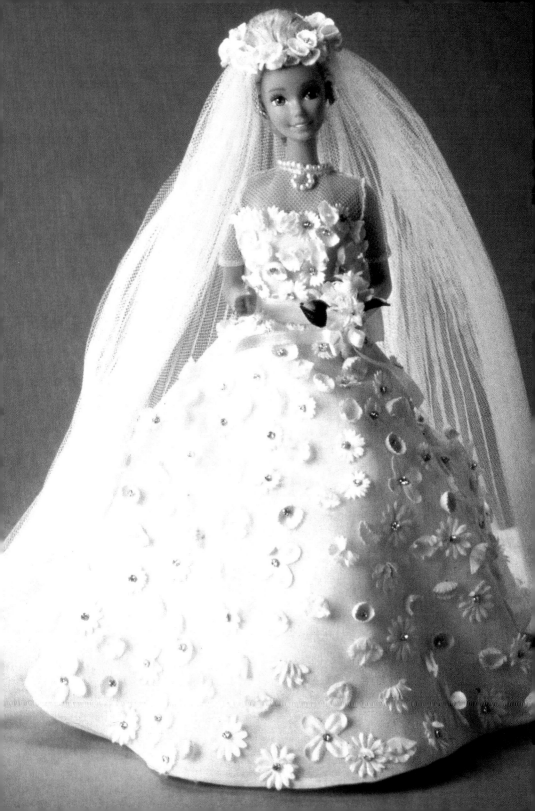

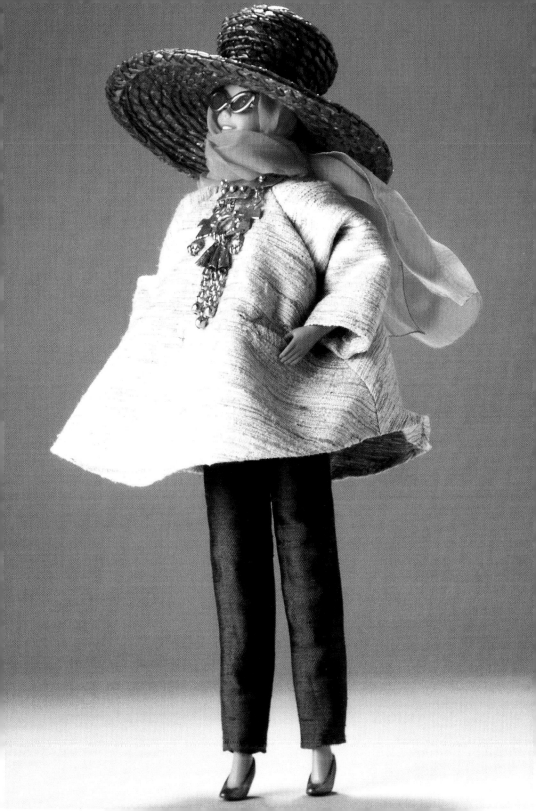

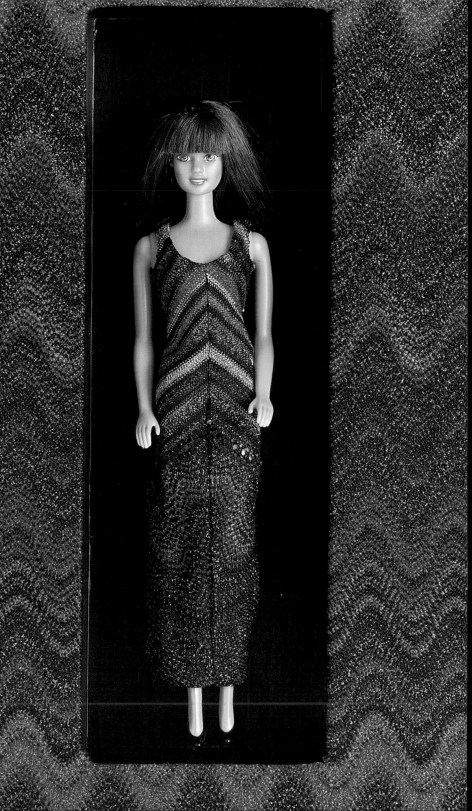

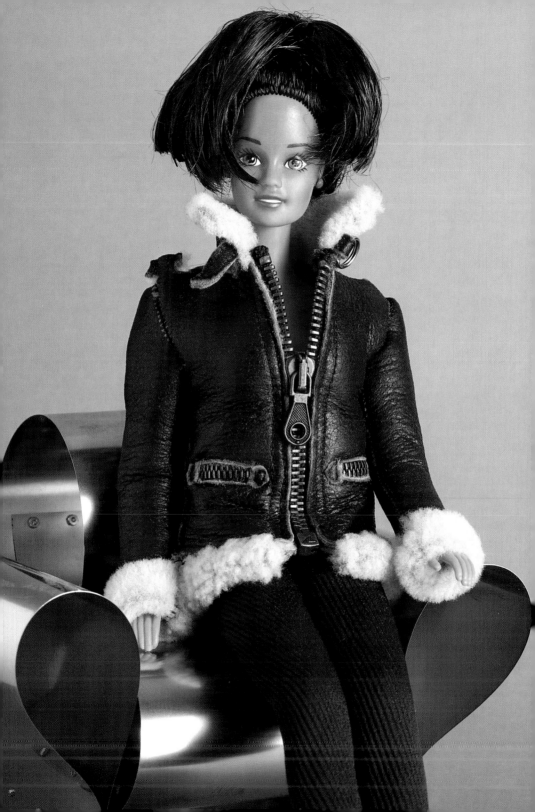

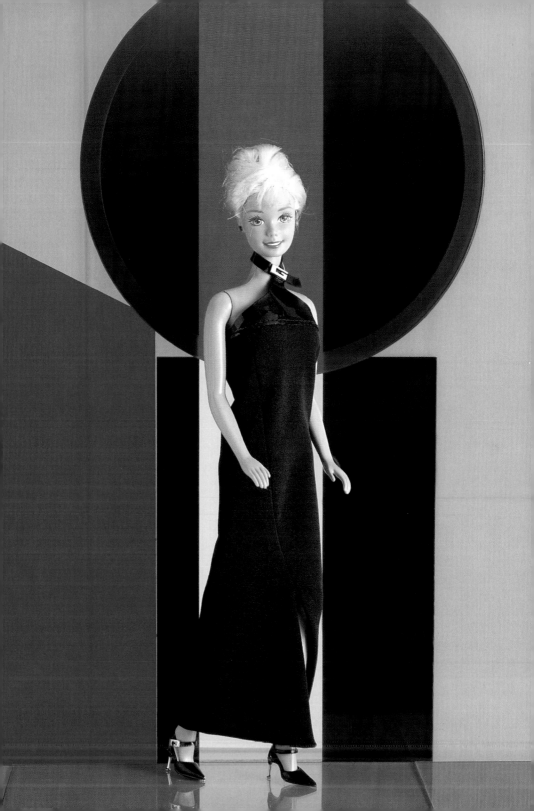

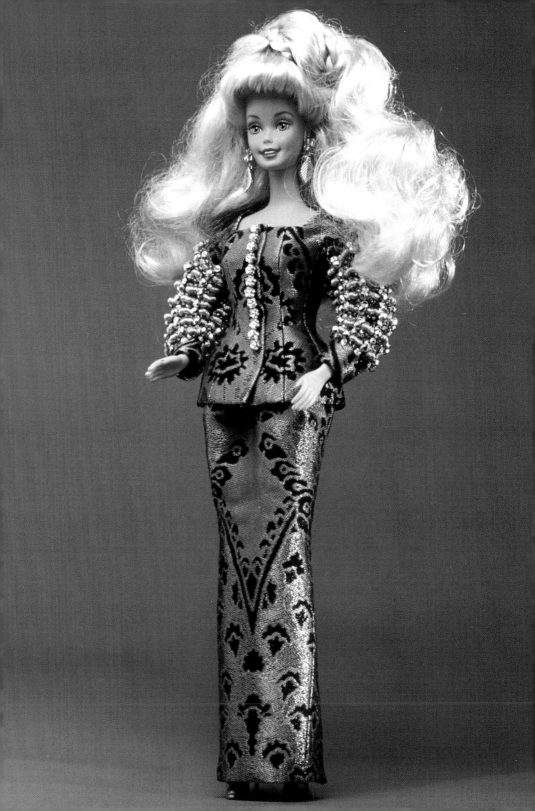

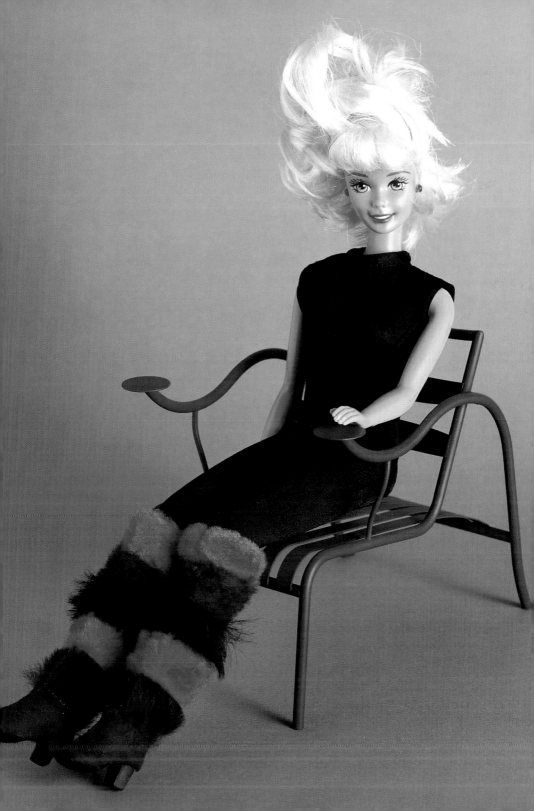

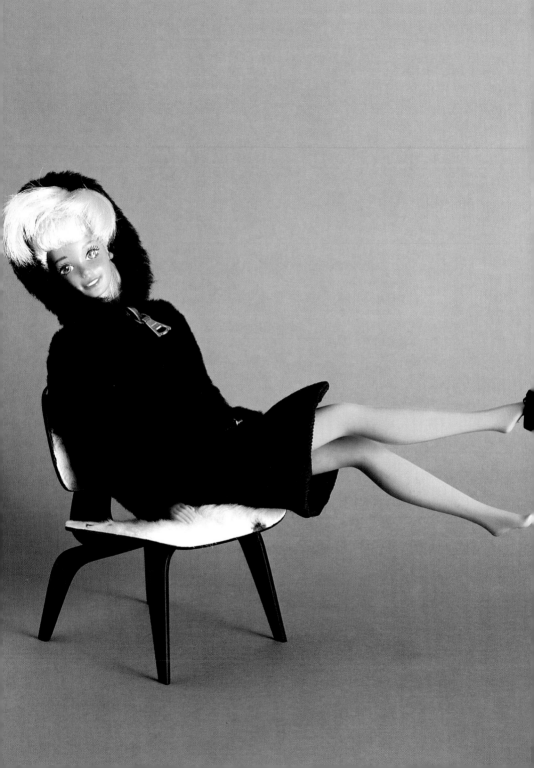

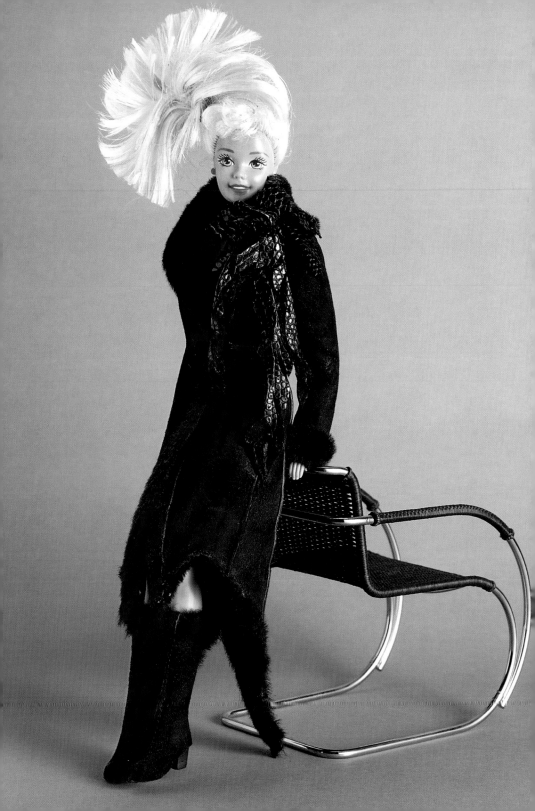

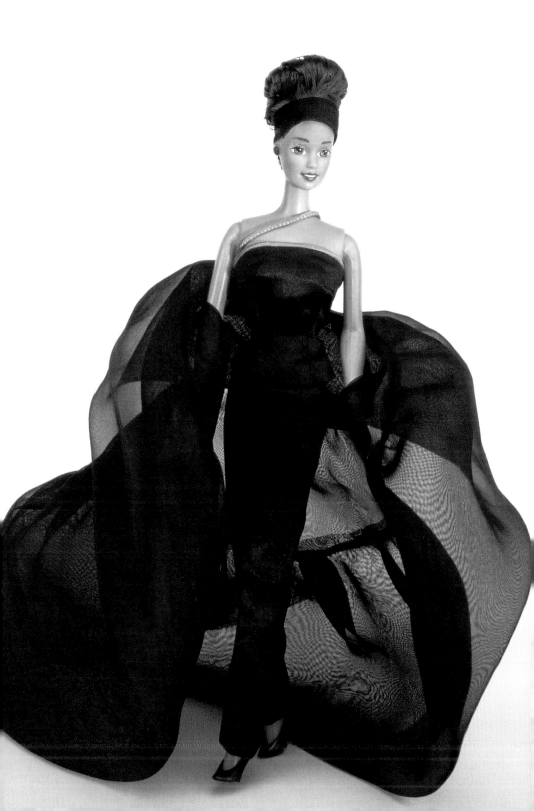

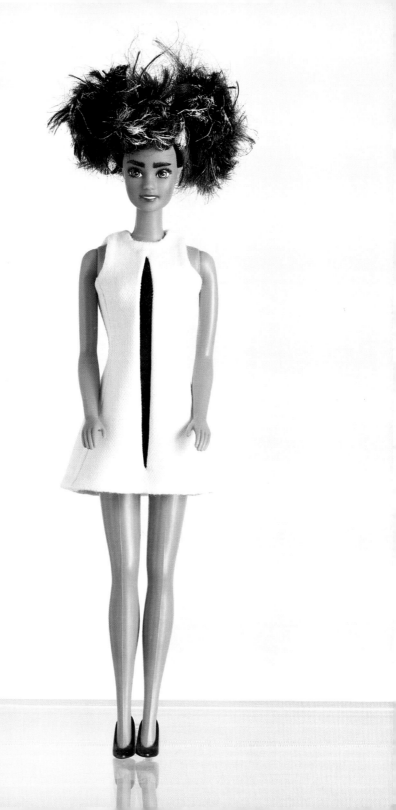

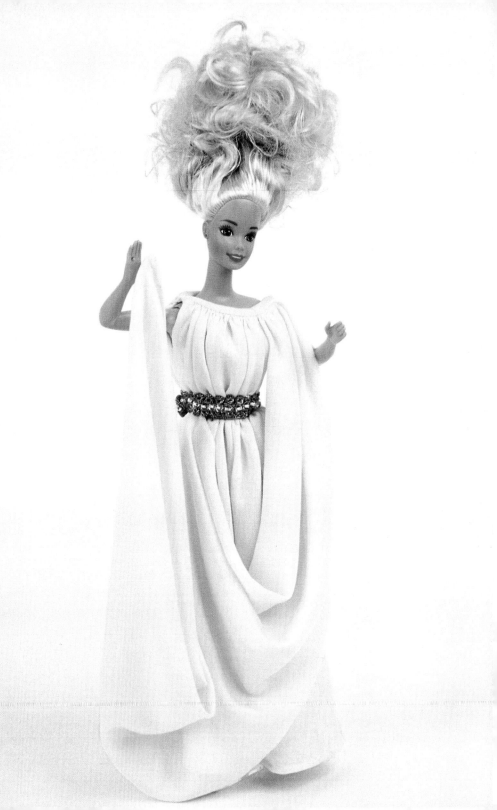

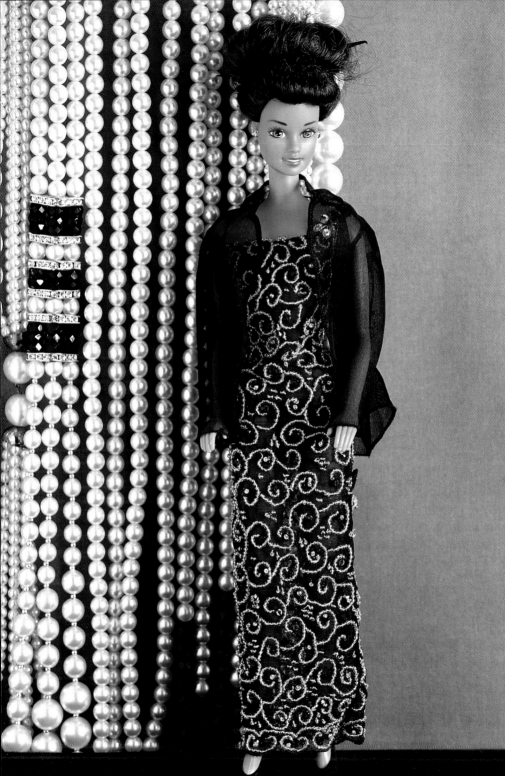

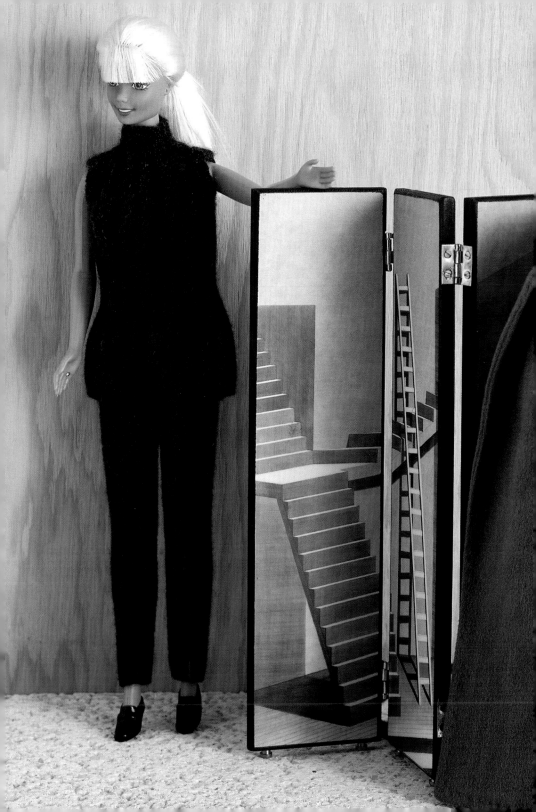

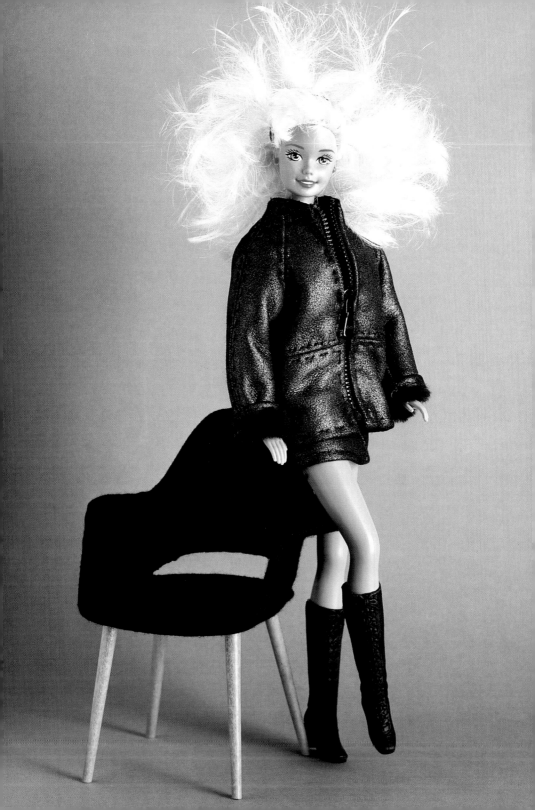

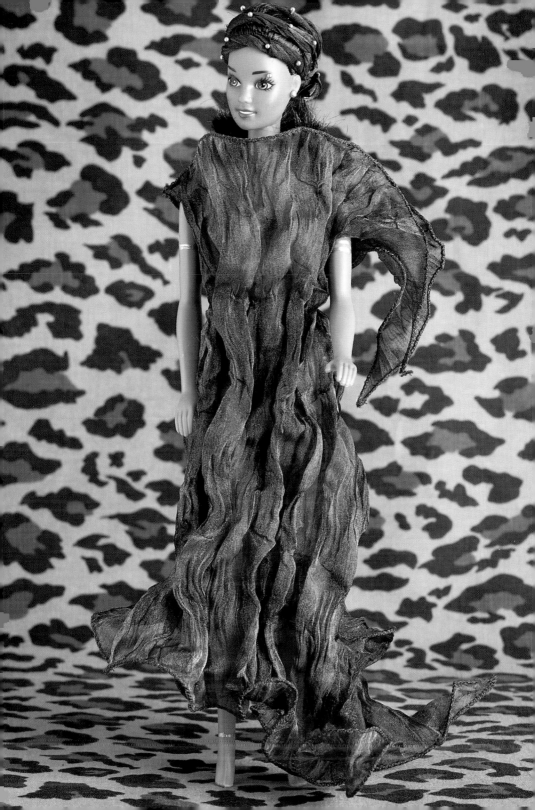

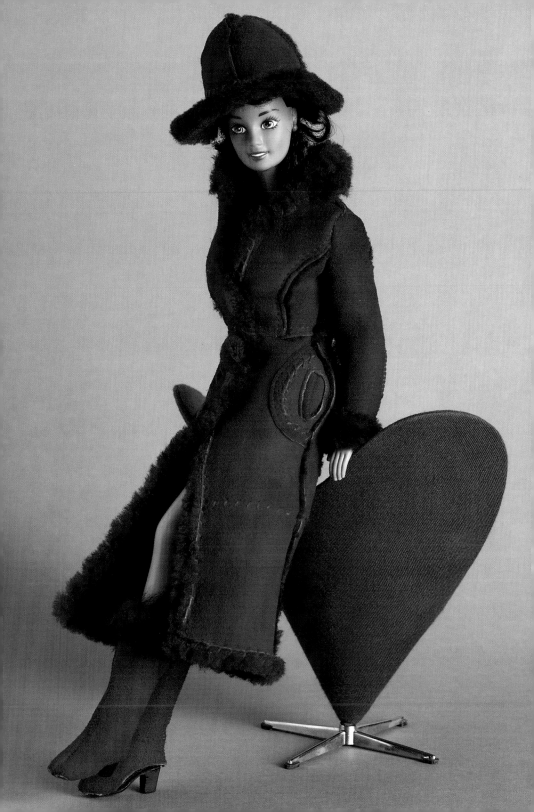

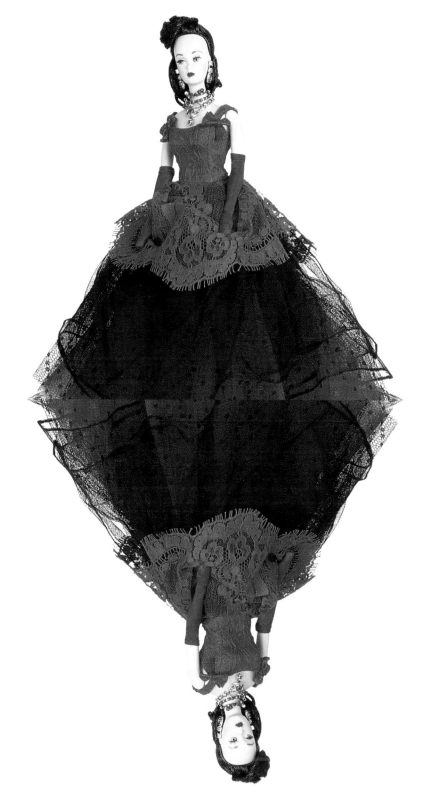

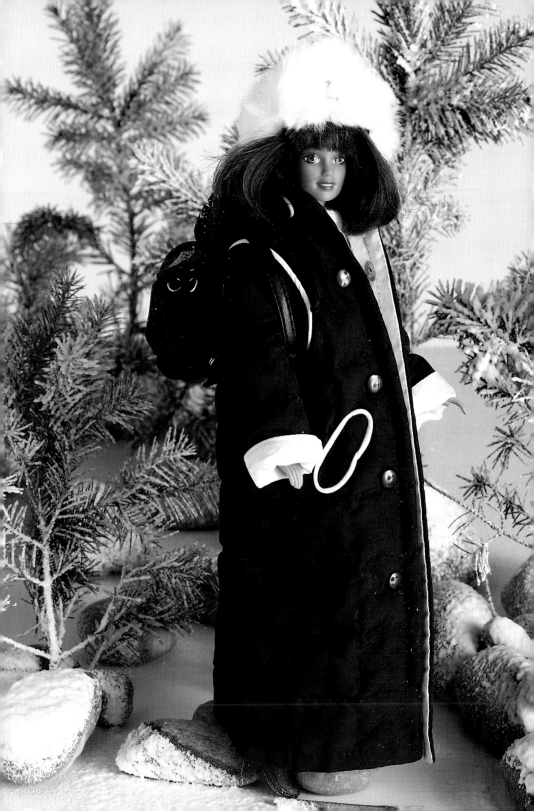

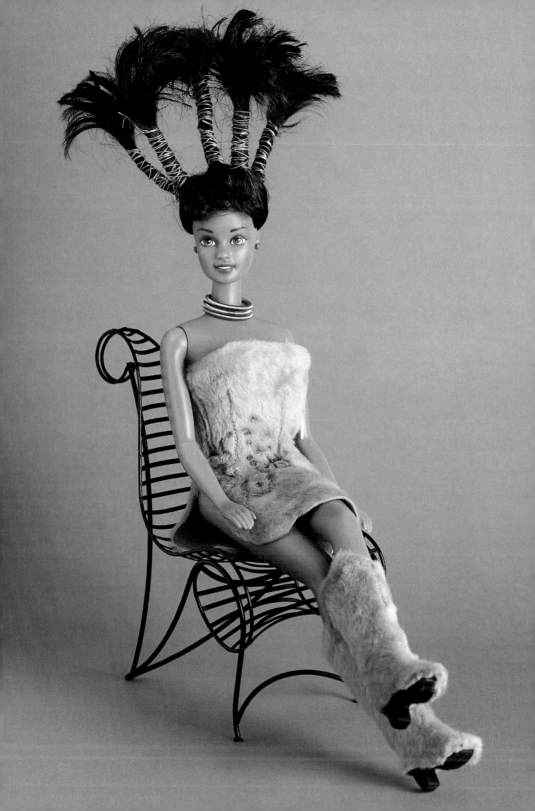

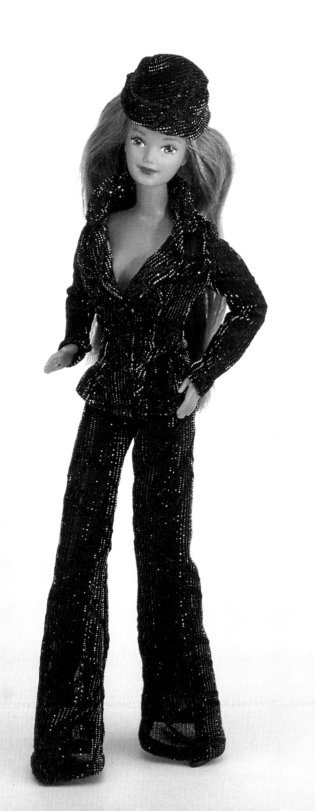

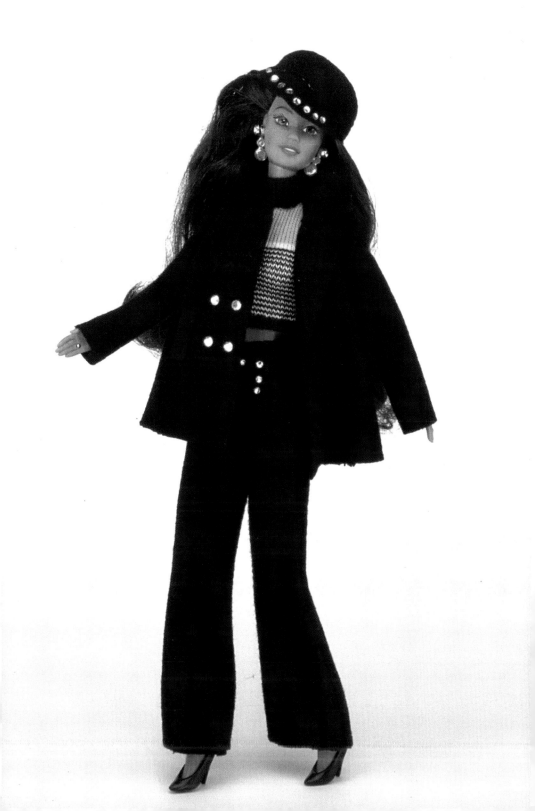

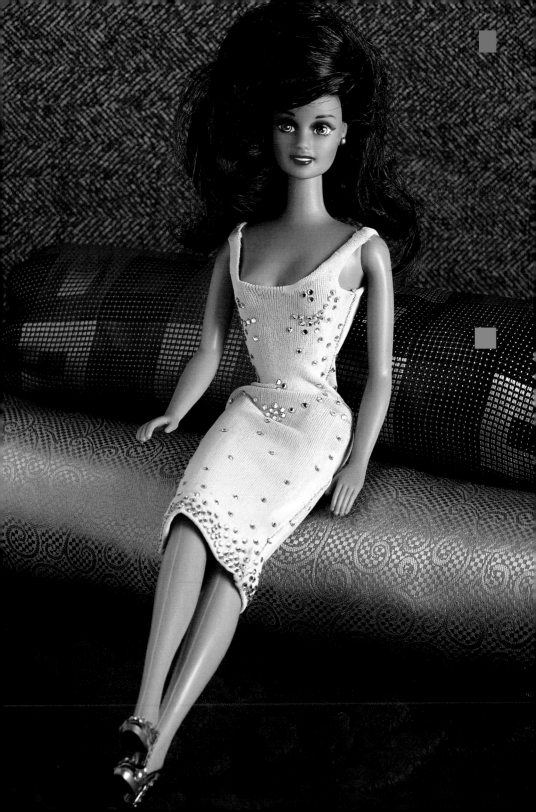

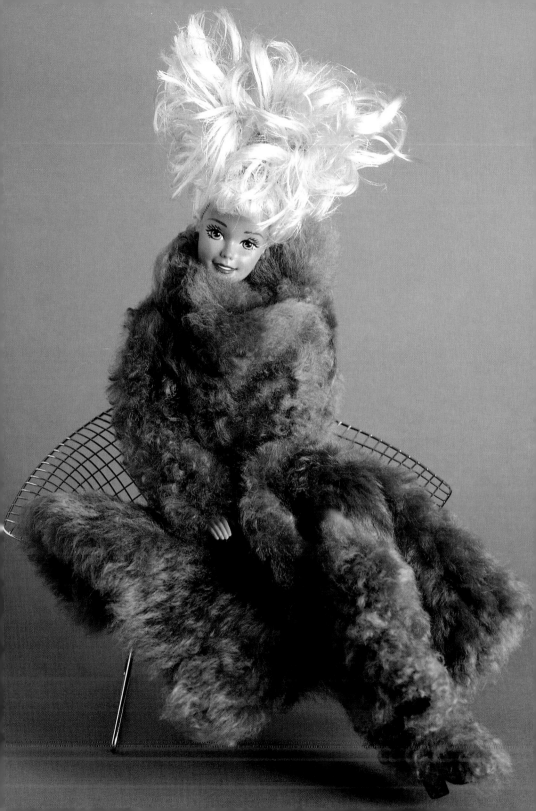

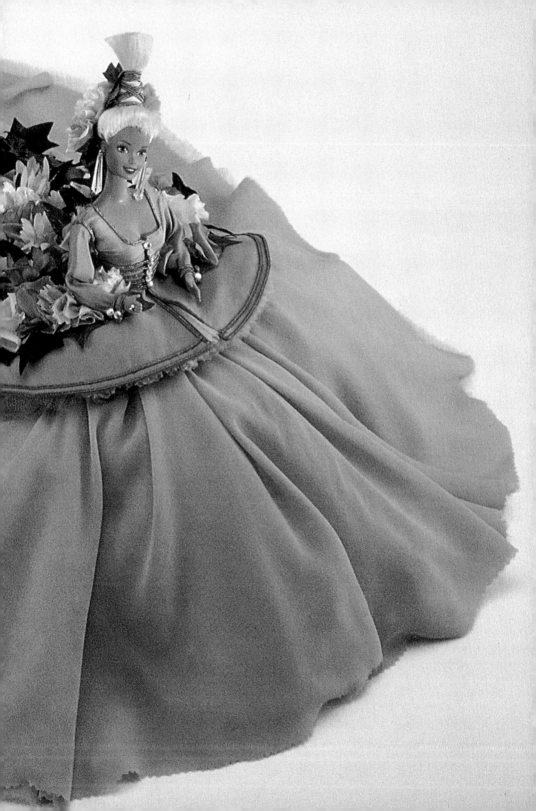

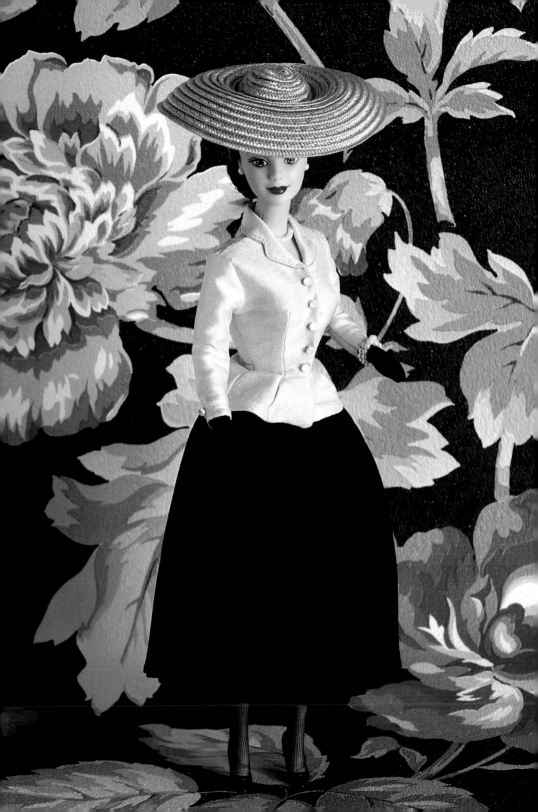

Chronology

1958: Elliot and Ruth Handler, founders of the American toy company Mattel, ask designer Jack Ryan to develop an adult doll, baptized Barbie, a nickname for Barbara–Ruth and Elliot's daughter.

1959: Barbie is born: ivory skin, almond-shaped blue eyes, heavy makeup, fantasy measurements (95-45-82), 29 centimeters tall. In March, Barbie is officially introduced at the Toy Fair in New York. Her sex appeal is a shock to America, but she very quickly makes her way into stores.

1961: Creation of Ken, her fiancé. Barbie keeps up with fashion, and sometimes even anticipates it; she has already switched from stockings to panty hose. She symbolizes the elegant woman (accessories, jewelry, cosmetics) and is the embodiment of American youth.

1963: Introduction of Midge, her freckled neighbor, who soon becomes her best friend. With "Barbie, Queen of Fashion," wigs appear, allowing her to vary her hairstyle. First fan club founded.

Following her introduction in France at the Foire de Lyon, Barbie has another surprise: After Jouets Rationnels attempts to distribute her, she is withdrawn from the market.

1964: Introduction of Skipper, Barbie's little sister, and Allan, Ken's friend. With the popularity of the Beatles, Barbie abandons haute couture for more contemporary outfits. Her new hairstyle is reminiscent of Brigitte Bardot.

1965: Now her legs are jointed—a technical innovation to be adopted by all model-type dolls.

1966: Keeping pace with the "yeah, yeah, yeah" era and the advent of feminine liberation, Francie, the "modern cousin," appears. Ken, with longer hair now, looks like Paul McCartney.

1967: The English supermodel Twiggy creates a new feminine ideal (boyish haircut, waiflike figure, wild outfits). Mattel is in touch with the times, introducing a Twiggy doll (striped minidress and yellow boots), perfect for wearing the miniskirt invented by Mary Quant. A testimony to the political upheaval in America, "Colored Francie" is born, to be replaced in 1968 by Christie, who is also black—she was taken out of production in 1985.

1970: By the beginning of the 1970s, people are liberating themselves from established customs, and Barbie wears a maxicoat rather than exquisite lingerie. At the same time, the stereotype of the businessman is developing: Ken, more sporty and tanned, now resembles Robert Redford.

1972: Robert Gerson, the director of Mattel France, a newly created company, acquires distribution rights, marking the inauguration of an era of extraordinary growth in France.

1973: A new Ken appears: long hair, beard, moustache, and sideburns.

1975: Fast-breaking technical innovations. Using a system of movable parts, Skipper can grow taller.

1976: On the occasion of the Bicentennial celebration in the United States, Barbie is placed into a time capsule which is not to be opened until the Tricentennial, so that future generations will be able to see how women of the previous century looked. This is the triumph of the "Barbie look": With roller skates on her feet, the doll is ready to confront a new epoch.

1977: Barbie remakes her face and is soon imitated by her friend Christie. She becomes "Super Star Barbie."

Introduction of giant (45 centimeters) Barbies and Christies.

1978: Introduction of "Super Star Ken": a new face and new jointings (he can turn his head and chest).

1979: Now Barbie can blow kisses (with the touch of a finger) and put on her own makeup. Skipper's face is more mature ("Super Teen Skipper" model).

1980: Introduction of the "International Barbies" (Italian, French, and English). Super Woman ahead of her time, Barbie works on a computer, pays with credit cards. . . meanwhile taking cooking classes.

1985: She transforms herself into a business woman: pink suit and attaché case. A "braider" allows her to wear her hair in braids. The introduction of new accessories transforms her daily routine—gym, whirlpool bath, film studio, etc.

1987: Barbie can now select from a wardrobe of twenty-four jewels and twelve haute couture outfits (the first had been created a year earlier by Oscar de la Renta). She works in her own travel agency or anchors television news when she's not busy putting on a concert with her new friends Derek and Diva.

1988: New "Bibop" dolls, sporting a fifties look and dancing bebop, enlarge Barbie's circle of friends.

1989: "Super Style Barbie," "Romantic Barbie," "Jeans," "Safari," "Promenade," "Sun Magic," or "Tropical." The pace of her life continues to quicken: a star's dressing room, a music studio, safari equipment including an all-terrain vehicle, a tropical bungalow, a scooter, etc.

Marking her thirtieth birthday, French designers and hairstylists create exclusive designs for her.

1990: With the opening of frontiers and the cultural crosscurrents of the nineties, Barbie dresses in Benetton and makes new friends on other continents. She becomes an ambassador for a better world, organizing the Barbie Summit, which mobilizes children all over the planet to enter a drawing contest based on the theme "The world would be better if. . . "

1991: The Magic Van, her camper, is enormously successful (over 250,000 models sold).

1992: "Ultra Long Hair Barbie" (with hair down to her ankles) is a triumph. She also transforms herself into a mermaid and dwells in a Magic Villa.

1993: Introduction of a talking Barbie (with a repertoire of forty thousand sentences), twins Stacie and Tom, their brother and sister, as well as four nieces.

On her thirty-fifth birthday on December 1, Barbie is admitted to the Musée Grevin, dressed by Gianfranco Ferré for Christian Dior with hair by Alexandre de Paris.

1994: Introduction of "Sweet Dreams Barbie," the first doll with a flexible body.

1995: In France, introduction of the first line of collectible Barbies.

On the occasion of an exhibition at the Chateau de la Poupée near Lyon, famous couturiers and designers create original outfits for her.

1997: Since her creation in 1959, a billion Barbies have been sold worldwide (a record in the toy market).

On November 27 in Milan, Christie's organizes an auction of dolls dressed by about forty great couturiers and designers to benefit the war against breast cancer. The event is called "A Barbie Today to Save a Woman Tomorrow."

1998: Exhibition at the Musée de la Poupée in Paris (June 19-September 20): Barbie on vacation.

Exhibition at the Chateau de Chamerolles (July 3-September 20) of the collection of 110 Barbie dolls dressed by the greatest couturiers and designers.

Dolce & Gabbana. Black satin wasp-waist dress with overstitching. Long stole of bicolored tulle and marabou, narrow ribbon with heart-shaped pendant. © Photo: Helbert Noorda/Italian Vogue.

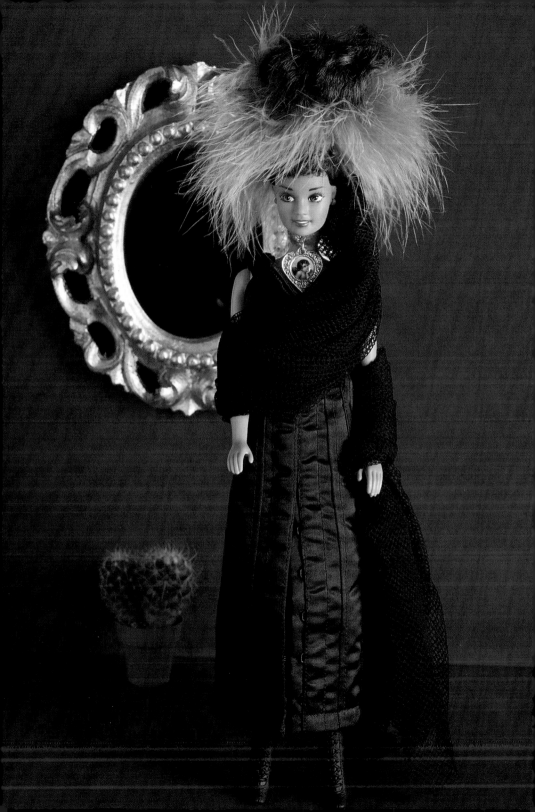

Barbie

First doll from the 1960s, 1959. One-piece black-and-white striped swimsuit. © Mattel France. **Benetton:** 1992 Barbie, Christie, Ken, Teresa, and Marina in Benetton, dressed in the Italian designer's 1992 styles: sweater, jacket, scarf, beret, and hood, all in vivid colors which highlight the beauty of the various complexions of these new dolls from different countries. United Colors of Benetton. © Mattel France.

One-piece swimsuit, 1964. Silk'n Flame, 1992: Velvet coat and hat. **Lolita Lempicka,** 1995: Flaring crepe dress. **Red cloth suit** with slim skirt and striped blouse, 1960. **Sequined black sheath** with tulle flounce, 1960. **Barbie in the 1980s.** Twiggy. In 1967 the supermodel from London created a new feminine ideal. © Mattel France, except for Silk'n Flame. © Photo: Helbert Noorda/Italian Vogue.

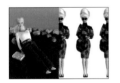

Levi's V-neck T-shirt in ribbed cotton and five-pocket jeans in blue denim, leather belt. © Photo: Helbert Noorda/Italian Vogue.
Christian Dior, 1995. Panther-print knit sheath dress with black velvet. Quilted panther-print stole with sheared mink, matching bag. Model from the Ready-to-Wear Collection, Fall/Winter 1995–1996. © Mattel France.

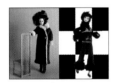

Jil Sander. Black shearling coat with beige short-pile faux fur, side button closure. Chair by Frank Lloyd Wright. © Photo: Helbert Noorda/Italian Vogue. **Sonia Rykiel,** 1995. " Rhinestone Barbie, Feather Barbie, Barbie my love." © Mattel France.

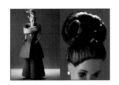

Claude Montana, 1989. Jacket with straps, portrait neckline, broad draped collar over wide trousers in grey linen. © Mattel France. **Hair by Alexandre.** Diva chignon. © Mattel France.

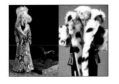

Trussardi. Full-length python coat, asymmetric knit sweater, and black leather pants. © Photo: Helbert Noarda/Italian Vogue.
Jean-Charles de Castelbajac, 1989. Innovatively structured full-length coat, lined with spotted fur and decorated with hand-sewn pop art badges. © Mattel France.

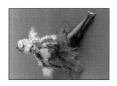

Coveri You Young. Short tutu-style Lolita dress in organdy embroidered with flowers. © Photo: Helbert Noorda/Italian Vogue.

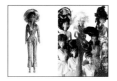

Junko Shimada, 1995. Gold python jumpsuit. © Mattel France.
Collection of hairstyles, 1995. To celebrate the March introduction of the "Cut and Style" Barbie, the first doll with "styleable" hair, famous hairstylists created original looks. Alexandre de Paris, Alexandre Zouari, Carita, Jacques Dessange, Jean-Claude Biguine, Jean-Louis David, Jean-Marc Maniatis, Lucie Saint-Clair, Mod's Hair, Patrick Alès. © Mattel France.

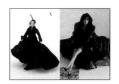

Hermes, 1997. Black wool crepe jacket, silk evening skirt, black riding boots by John Lobb. © Mattel France.
Fendi. Coat with moleskin and openwork bands, sheath in sequined bronze cloth, black crocodile handbag. © Photo: Helbert Noorda/Italian Vogue.

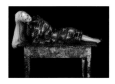

Prada. Coat of subtly shaded Panama cloth, embroidered with beads.
© Photo: Helbert Noorda/Italian Vogue.

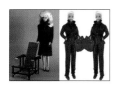

Alberto Ferretti. Coat in shearling and short pile tone-on-tone faux fur with net bands and magnet closure. Armchair by Gerrit T. Rietveld. © Photo: Helbert Noorda/Italian Vogue.
Hermes, 1995. Riding jacket and pants with gaiters in soft lambskin, man's shirt with twill tie in "Festival" print, John Lobb riding boots, Birkin bag in Gulliver calfskin. © Mattel France.

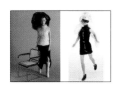

Calvin Klein. Frosted short pile shearling vest, slit skirt in wool jersey. Chair by Marcel Brauer. © Photo: Helbert Noorda/Italian Vogue.
Agnès B, 1997. "I love movies" sheath dress with high collar in silk-screened Lycra jersey. © Mattel France.

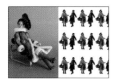

Jean-Paul Gaultier. Beige shearling parka with white faux fur, exposed seams, overstitched with black fabric bands. Armchair by Alvar Aalto.
© Photo: Helbert Noorda/Italian Vogue.
Cacharel, 1977. Traveling twins. Long silk skirt, mohair cardigan, cashmere coat, and beret. Short silk skirt, T-shirt, long coat, and mohair scarf. 1997–1998 Fall/Winter Collection. © Mattel France.

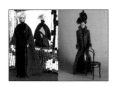

Christian Lacroix. Suede cape with multicolored mosaic motif on back, long crocodile leather sheath. © Photo: Helbert Noorda/Italian Vogue.
Dolce & Gabbana. Full-length shearling coat, leopard lining, hook closure. Chair by Michael Thonet & Sahne. © Photo: Helbert Noorda/Italian Vogue.

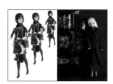

Emanuel Ungaro, 1995. Leopard theme from the Ready-to-Wear Collection, Fall/Winter 1995–1996. Here is the truly sensuous Ungaro woman, lively and nonconformist, always in style. © Mattel France.
Alberta Ferretti. Charcoal grey wool coat with matching shoes, polo-neck sweater, skirt embroidered with beads. © Photo: Helbert Noorda/Italian Vogue.

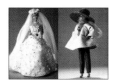

Nina Ricci, 1989. Wedding gown in flower appliqué embroidered organza, flower headpiece over a point d'esprit veil. © Mattel France.
Christian Lacroix, 1989. A Riviera-look ensemble in brown and beige chiné fabric, accessorized with sunglasses, a large hat, a mousseline scarf, and jewelry. © Mattel France.

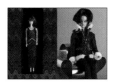

Missoni. Long-stretch knit body dress with lurex patchwork. Hair by Marc Lopez. Doll is displayed in an alcove covered with the same fabric. © Photo: Helbert Noorda/Italian Vogue.
Azzedine Alaia. Brown zippered shearling windbreaker with lighter-colored faux fur, stretch knit pants. Armchair by Ron Arad. © Photo: Helbert Noorda/Italian Vogue.

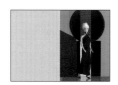

Gucci. Stretch black evening gown, shoes with straps and buckles, steel heels. © Photo: Helbert Noorda/Italian Vogue.

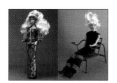

Gianfranco Ferré for Christian Dior. To celebrate her admission to the Musée Grevin, Barbie is dressed in a "made-to-order" suit with long sheath skirt in black brocade and sleeves embroidered by Maison Vermont. 1993–1994 Fall/Winter Collection. Hair and jewelry by Alexandre de Paris. © Mattel France.
Manolo Blahnik. Synthetic leather boots banded with faux fur. Stretch knit pants and top. Armchair by Jasper Morrison. © Photo: Helbert Noorda/Italian Vogue.

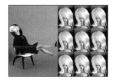

Marc Jacobs. Black faux-fur jacket with Eclair closure and hood, ribbed knit dress. Chair by Charles and Ray Eames. © Photo: Helbert Noorda/Italian Vogue.
Marina Spadafora. Handmade passementerie coat worn over a stretch dress. © Photo: Helbert Noorda/Italian Vogue.

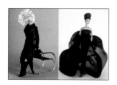

Alessandro Dell'Acqua. Shearling-trimmed coat with deep-pile wool lining and a black leather snakeskin flower appliquéd on the back. Armchair by Mies van der Rohe. © Photo: Helbert Noorda/Italian Vogue.

Balenciaga, 1997. Satin crepe jumpsuit worn under a silk organza evening coat. Silk organza turban. Fall/Winter Collection 1962–1963 by Cristobal Balenciaga. © Mattel France.

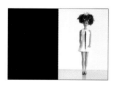

Milo Schon. Short wool dress, "Fountain" cut, with vertical slit. Hair and make-up by Aldo Coppola. © Photo: Helbert Noorda/Italian Vogue.

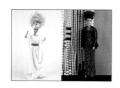

Grès, 1995. Draped gown in silk jersey, Greco-Roman style. Hair by Alexandre de Paris. © Mattel France.

Giorgio Armani. Evening gown in transparent silk tulle, hand-embroidered with beads and jewels, organdy jacket, faux-gem brooch, and earrings. Hair and makeup by Armani. © Photo: Helbert Noorda/Italian Vogue.

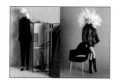

Max Mara. Cashmere knit ensemble with cable stitching. Hair by Orlando Pita. © Photo: Helbert Noorda/Italian Vogue.

Gianni Versace. Zipped biker jacket and skirt in purple laminated shearling with exposed seams. Chair by Charles Eames.
© Photo: Helbert Noorda/Italian Vogue.

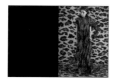

Krizia. Asymmetric evening gown in pleated metallic organdy, beaded turban.
© Photo: Helbert Noorda/Italian Vogue.

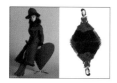

Anna Sui. Shearling short-pile tone-on-tone coat with coordinating hat and boots. Armchair by Werner Panton. © Photo: Helbert Noorda/Italian Vogue.

Lolita Lampicka, 1995. Boned bustier, laced in back, in iridescent taffeta covered with lace, tulle petticoat with red and black satin stitching, overlaid with raspberry Chantilly lace, red satin gloves, and colored bead necklace.
© Mattel France.

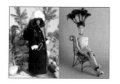

Iceberg. Full-length black-and-white coat in lined, quilted cotton, sweater, and miniskirt, fur hat and backpack. © Photo: Helbert Noorda/Italian Vogue.

Alexander McQueen for Givenchy. Minidress in short-pile faux fur with flower print, coordinating boots. Chair by Andre Dubreuil.
© Photo: Helbert Noorda/Italian Vogue.

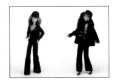

Corinne Cobson, 1997. Copper lurex knit jumpsuit. © Mattel France.
Dorothée Bis by Jacqueline Jacobson, 1997. Jacket, hipster pants, and cap in navy blue, faux gem buttons, cropped sleeveless sweater in striped wool. © Mattel France.

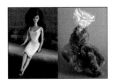

Lawrence Steele. Knit sheath and shoes embroidered with Swarovski Crystal. Hair by Ward. © Photo: Helbert Noorda/Italian Vogue.
Vivienne Westwood. Coat with asymmetric sleeves in long-pile faux fur, coordinating boots. Chair by Harry Bertola. © Photo: Helbert Noorda/Italian Vogue.

Louis Féraud, 1997. The governor's ball. Close-fitting jacket in green silk faille trimmed with gold braid and stitched with roses, full triple skirt in green organza highlighted with gold. Haute Couture Collection, Spring/Summer 1996. © Mattel France.

Barbie has inspired all the greatest couturiers and designers in the history of the world. The editor has been forced to make some difficult choices for this book. We trust those who were omitted will be understanding.

The editor thanks Franca Sozzani and Helbert Noorda for all their help in completing this work, together with Mattel, and especially M. Giambalvo, Elizabeth Dubost, Isabelle Gauquelin, Constance Dubois, and Sylvie Gotlibowicz.

Thanks are also owed to all of those who consented to help with this book on Barbie and fashion, most particularly to the couturiers and designers Azzedine Alaïa, Giorgio Armani, Agnès B., Balenciaga, Benetton, Manolo Blahnik, Cacharel, Jean-Charles de Castelbajac, Corinne Cobson, Coveri You Young, Alessandro Dell'Acqua, Christian Dior, Dolce & Gabbana, Dorothée Bis, Fendi, Louis Féraud, Alberta Ferretti, Jean-Paul Gaultier, Givenchy, Grès, Gucci, Hermès, Iceberg, Marc Jacobs, Calvin Klein, Krizia, Christian Lacroix, Lolita Lempicka, Max Mara, Missoni, Claude Montana, Prada, Nina Ricci, Sonia Rykiel, Jil Sander, Mila Schon, Junko Shimada, Marina Spadafora, Lawrence Steele, Anna Sui, Trussardi, Emanuel Ungaro, Gianni Versace, and Vivienne Westwood, as well as the hairstylists Patrick Alès, Alexandre de Paris, Jean-Claude Biguine, Carita, Jean-Louis David, Jacques Dessange, Jean-Marc Maniatis, Mod's Hair, Lucie Saint-Clair, and Alexandre Zouari.